To My Dear Alison

May this book bring a little
peace & tranquility to your life

Love Your Tony

26-12-93

XO

Degas

A THOMAS NELSON BOOK

First published in 1993 by Thomas Nelson Publishers, Nashville, Tennessee.

Copyright © 1993 by Magnolia Editions Limited

10 9 8 7 6 5 4 3 2 1

Library of Congress Cataloguing in Publication Data is available.

Library of Congress Card
93-83513

ISBN 0-7852-8305-6

MINIATURE ART MASTERS
IMPRESSIONISTS: DEGAS
was prepared and produced by
Magnolia Editions Limited,
15 West 26th Street, New York, N.Y. 10010

Editor: Karla Olson
Art Director: Jeff Batzli
Designer: Susan Livingston
Photography Editor: Ede Rothaus

Printed in Hong Kong and bound in China

Degas

Gerhard Gruitrooy

NELSON REGENCY
A Division of Thomas Nelson, Inc.

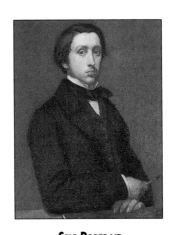

Self Portrait
1854–1855; Oil on canvas;
31 ⅞" × 25 ¼" (81 × 64 cm);
Musée d'Orsay, Paris

Introduction

Edgar Degas' role is different in several ways from that of other celebrated Impressionists. He certainly followed the true goal of Impressionism: to achieve greater naturalism and capture the play of light on the surface of objects. However, he did not follow the Impressionistic color theory that an object casts a shadow of its complementary color. Nor did he paint outdoors *(en plein air)*, preferring instead to depict such aspects of contemporary Parisian life as the ballet (for which he is perhaps best known), race tracks, and women bathing or shown in domestic activities. Furthermore, he stressed composition and drawing, frequently making preparatory sketches, a practice that conflicted with Impressionist methods.

Still, like all Impressionists, Degas was constantly trying to give permanence to a passing moment of life. To achieve this goal he concentrated on movement, rather than color or atmosphere. Often painting from unusual vantage points, he let his figures be cut off at the edge of the canvas to emphasize the continuing space and movement. In so doing, he was probably influenced by the style of Japanese woodblock prints, popular in artists' circles at the time, as well as by the new medium of photography.

Degas' career also differed from that of other Impressionists in that he was born into a wealthy family and was economically independent right from the start. He was the eldest of five children, the son of a banker and amateur organist who cultivated a love for the fine arts in each member of his family. His mother was a Creole woman from New Orleans

who died when he was thirteen. The correct—and aristocratic—form of his surname is De Gas, but he changed it early on to the more bourgeois Degas, probably to bridge the social gap between him and his subjects, usually people of the lower classes.

While a young man, Degas entered law school, but studied the Old Masters in the Louvre, namely Albrecht Dürer, Francisco de Goya, and Rembrandt. In 1854 he began formal training in the studio of a former pupil of Jean Auguste Dominique Ingres (1780—1867), whose precise draughtsmanship he admired. After a brief enrollment in the Ecole des Beaux-Arts, Degas traveled to Florence in 1856, where he spent some time with his aunt's family. There he copied the works of the Renaissance masters. By the middle of the 1860s, under the influence of Edouard Manet and other young Impressionist painters, among them Auguste Renoir,

Claude Monet, and Camille Pissarro, Degas turned to more contemporary subjects, such as theater scenes and café concerts. This "Manet gang," as it was called by some critics, met regularly at the Café Guerbois, where they discussed the need to represent modern life in art. Their approach favored outdoor painting, spontaneity, and direct observation rather than the traditional studio work. But Degas disdained the *en plein air* philosophy, insisting that initial impressions must be refined and recreated from memory to discard unnecessary details. He believed that he could thus achieve greater realism by concentrating on the dominant character of his subject.

Despite these differences, Degas participated in all but one of the eight Impressionist exhibitions, for they were his only chance for a wider public to see his works. Many early viewers condemned the artist as a

misogynist, contending that he was attempting to debase or humiliate women. But his paintings are actually realistic, objective expressions of his fascination with bodies in motion.

During the last twenty years of his life, Degas' eyesight worsened, but for some time he was still able to model small wax sculptures of ballet dancers, horses, and nudes, which were cast in bronze after his death. His extraordinary grasp of balance and the vital tension of these sculptures were acknowledged by August Renoir, who once described Degas as the greatest sculptor of the nineteenth century.

Degas instructed his friend Jean-Louis Forain that no eulogy be held at his funeral, but "if there has to be one, you, Forain, get up and say 'he greatly loved drawing; so do I,' and then go home."

ACHILLE DE GAS AS MARINE CADET

1859–1862; OIL ON CANVAS;
25 3/8" × 18 1/4" (64.5 × 46.2 CM);
NATIONAL GALLERY OF ART,
WASHINGTON, D.C.

This is a portrait of the artist's younger brother, a student at the Naval Academy. He is dressed rather ostentatiously in the striking uniform of a midshipman. An unruly and impulsive character—he was temporarily threatened with dismissal for insubordination—Achille later became disappointed with the uneventful Navy life and resigned. Together with his brother René he founded the firm of De Gas Brothers in New Orleans (see page 28).

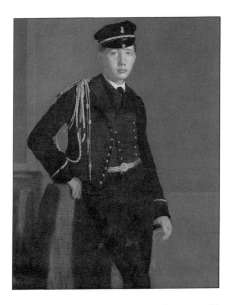

THE BELLELLI FAMILY

1858–1867; OIL ON CANVAS;
78 ³/₄" × 98 ³/₈" (200 × 253 CM);
MUSÉE D'ORSAY, PARIS

At the time of Degas' death this painting, still in his studio, was in poor condition; however, it unexpectedly became the highlight of the 1918 Salon. During his first sojourn in Italy, Degas spent some time in Florence with the family of his uncle Gennaro Bellelli, who was temporarily exiled from Naples. This painting took years of preparatory studies and sketches, and was probably not finished before the Salon of 1867. This family scene is more than a portrait, it is a heroic rendering of the psychological relationships the sitters had with each other. Degas' aunt Laura suffered from mental instability.

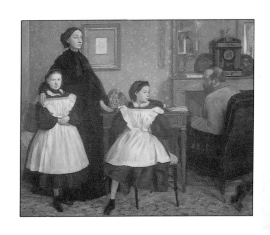

The Artist and his Friend Evariste de Valernes

CIRCA 1865; OIL ON CANVAS;
45 ⅝" × 35" (116 × 89 CM);
MUSÉE D'ORSAY, PARIS

This is Degas' last self-portrait, showing himself in company of his painter friend Valernes, who was about twenty years his senior. Although Valernes was unsuccessful in his career and on the brink of poverty, Degas must have enjoyed the company of this affable gentleman, with whom he shared a passionate admiration for Delacroix. The older man appears to be self assured and balanced ("You have always been the same man, my old friend..." Degas later wrote to Valernes), while the questioning eyes and the hand raised to his chin express the insecurity and hesitation of the younger artist.

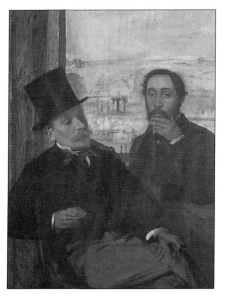

THE FALLEN JOCKEY

CIRCA 1896–1898; OIL ON CANVAS;
71 ¼" × 59 ½" (181 × 151 CM);
ÖFFENTLICHE KUNSTSAMMLUNG,
KUNSTMUSEUM, BASEL

A scene from "real" life, a horse-riding accident, has been enlarged to heroic proportions. An abbreviated, almost abstract landscape is defined only by the declining line of a hill and the cloudy sky. A frightened runaway horse bursts through the picture. In the foreground, the bearded jockey lies flat and lifeless on his back. The accident appears to be fatal. The spare, forthright treatment of the scene results in a picture compelling in its outright emotion.

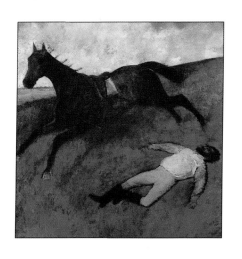

Portrait of Joséphine Gaujelin

1867; Oil on canvas;
24 ⅛" × 18" (61.2 × 45.7 cm);
Isabella Stewart Gardner Museum,
Boston

The sitter, a ballerina who had commissioned the portrait, rejected the work, noting that it did not do her justice. Her pensive mood and black dress contrast with the livelier crimson color of the fabric surrounding her and the yellow wall in the background, which is divided into two parts. The objects on her dressing table show the viewer that she is a ballerina. Her eyes draw the viewer directly into the work.

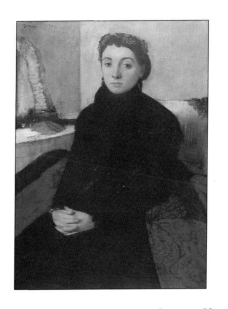

HORTENSE VALPINÇON

1871; OIL ON CANVAS;
29 $\frac{7}{8}$" × 43 $\frac{5}{8}$" (76 × 110.8 CM);
THE INSTITUTE OF ARTS, MINNEAPOLIS

The only daughter of one of Degas' old school-
mates, Hortense is pictured here in a quiet, middle-
class environment. The little girl leaning over a
table with a piece of apple in her right hand is
balanced by a still life of a sewing basket and an
unfinished piece of embroidery. The black cloth
with colorful floral motives was embroidered by the
girl's mother and adds a feeling of domesticity to
the scene. The angle of the table adds depth to the
otherwise flat background of wallpaper. One might
expect the impatient girl to run off any moment.

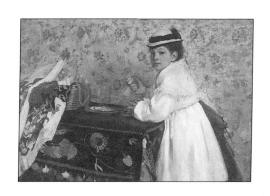

THE ORCHESTRA OF THE OPERA
CIRCA 1870; OIL ON CANVAS;
22 ¼" × 18 ¼" (56.5 × 46.2 CM);
MUSÉE D'ORSAY, PARIS

After its first showing in 1871, this painting disappeared from view for about half a century and caused a sensation at an exhibition at the Louvre in 1924, where it was immediately recognized as one of Degas' great masterpieces. Its former owner, the bassoonist Désiré Dihau, is seen at the center playing his instrument; other members of the orchestra can be identified as musicians of the Opéra or as friends of the artist. The composer Emmanuel Chabrier in the stage box is a later addition. This is a portrait of an individual within a group. Musicians of various features and expressions play undisturbed by the dancers on the stage.

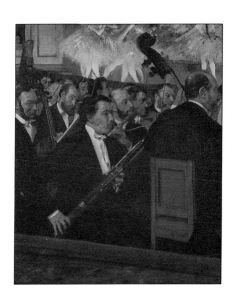

ORCHESTRA MUSICIANS

CIRCA 1870–1871, REWORKED
CIRCA 1874–1876; OIL ON CANVAS;
27 $\frac{1}{8}$" × 19 $\frac{1}{4}$" (69 × 49 CM);
STÄDELSCHES KUNSTINSTITUT, FRANKFURT

In this genre scene, the dancers are equal to their counterparts in the orchestra pit. In order to achieve this balance the artist added a strip of canvas on the top some years later and turned the dancers into full-length figures rather than ones cut off at the waist. Like the artist, the viewer is seated in the front row. As a result, the painting does not have a traditional panoramic perspective. The musicians are rendered in a precise, smooth technique, while the dancers appear in light, quick brushstrokes underlining the juxtaposition of two worlds: music and dance.

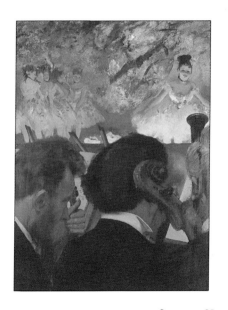

THE FOYER (DANCE CLASS)
1871; OIL ON PANEL;
7 ¾" × 10 ⅝" (19.7 × 27 CM);
METROPOLITAN MUSEUM OF ART, NEW YORK

Exhibited at the first Impressionist show in Paris in 1874, where it was received with favor, *The Foyer* is one of the first portraits of what was to become Degas' best-known subject: dancers. Since Degas did not have access to the backstage of the Opéra until about 15 years later, it is almost certain that he did not witness the scenes that he later depicted. However, he invited dancers to his studio, where he would execute many studies that were later used in various paintings. The dancer at the center before the mirror is Joséphine Gaujelin (see page 18).

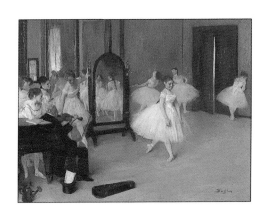

INTERIOR OF AN OFFICE IN NEW ORLEANS

1873; OIL ON CANVAS;
28 ³/₄" × 36 ¹/₄" (73 × 92 CM);
MUSÉE DES BEAUX-ARTS, PAU, FRANCE

This first painting by Degas to enter a museum (1878) differs from most other works in its realism and classic influences. After visiting his mother's family in New Orleans for three months, Degas undertook this group portrait, which includes family members and associates. His brother Achille (see page 10) is leaning against a counter on the left while his other brother, René, is reading the journal. At the center, two men, a broker and a buyer, are checking the quality of the cotton. Degas considered the work done at this time his "American" work.

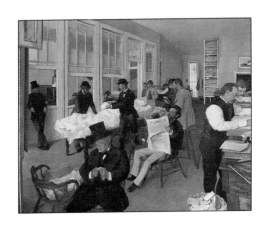

THE PEDICURE

1873; ESSENCE ON PAPER MOUNTED
ON CANVAS; 24" × 18 ⅛" (61 × 46 CM);
MUSÉE D'ORSAY, PARIS

A chiropodist is treating a young girl believed to be Joe Balfour (René De Gas' stepdaughter), which links this work to the artist's New Orleans visit. The painting itself, however, appears to have been executed in Paris in Degas' special painting technique that produced softer and more matte tones than did oil, quite flattering to the white cloth in which the girl is wrapped. Degas treated this unusual subject with great dignity and delicacy.

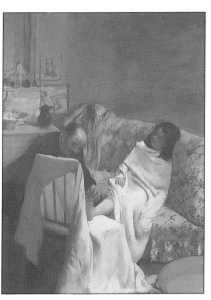

THE SONG REHEARSAL

1872–1873; OIL ON CANVAS;
31 7/8" × 25 5/8" (81 × 65 CM);
DUMBARTON OAKS RESEARCH LIBRARY,
WASHINGTON, D.C.

Most likely prepared during his stay in New Orleans, this interior is seen from a slightly raised angle, in the corner of a room that resembles the cotton office (see page 28). The singers cannot be identified with certainty; however, their theatrical gestures are typical of operatic divas. The daytime setting, with its clear light and bright yellow walls, is quite unusual. From early childhood on, Degas was accustomed to hearing musical performances in private homes. The white chair in the forefront was originally planned as a chaise longue.

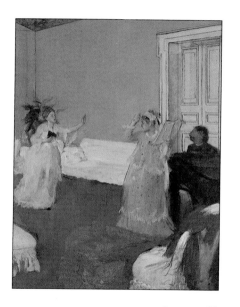

THE ABSINTHE DRINKER

1875–1876; OIL ON CANVAS;
36 ¼" × 26 ¾" (92 × 68 CM);
MUSÉE D'ORSAY, PARIS

When this painting was first exhibited in Brighton, England, in 1876, it was criticized for being a "very disgusting novelty of the subject" and for being executed in a "slap-dash" manner, alluding to its Impressionist technique. The artist's notebook indicates the names of the models, Hélène Andrée and the artist-etcher Marcellin Desboutin, one of Degas' friends. The subject was often seen to be objectionable, although the work appeared to others as "the inexhaustible picture the one that draws you back, and back again."

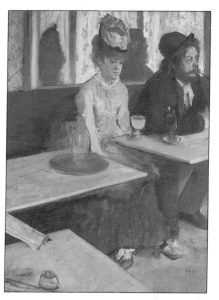

CONCERT AT CAFÉ DES AMBASSADEURS

1875–1877; PASTEL OVER MONOTYPE;
14 $\frac{1}{2}$" × 10 $\frac{5}{8}$" (37 × 27 CM);
MUSÉE DES BEAUX-ARTS, LYON

Unusual effects of light and bright colors are char-
acteristic of this work. The left arm of the singer
is foreshortened, drawing the viewer in. The
stage lights lined up behind the performer add
the illusion of depth. The Café des Ambassadeurs
was a highly popular club that served novelists
and writers as an arena for their publications.
Other artists, in particular Toulouse-Lautrec, also
immortalized the Café.

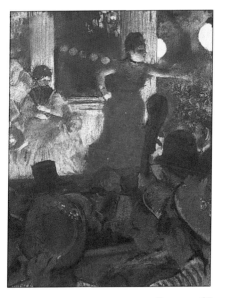

THE SONG OF THE DOG

CIRCA 1876–1877; GOUACHE AND PASTEL
OVER MONOTYPE ON PAPER;
22 ⁵/₈" × 17 ⁷/₈" (57.5 × 45.4 CM);
MUSÉE D'ORSAY, PARIS

Like Manet and many other artists, Degas was intrigued by the world of café-concerts, which offered musical entertainment besides the common attractions of a pub. The singer has been recognized as Thérésa (Emma Valadon), one of the great stars of the day. In Degas' own words her voice was "the most natural, the most delicate, and the most vibrantly tender" instrument. The singer's stout body is encased in a tight dress, her hands are hanging down like paws sharply lit by invisible footlights, and she is seen from the closest possible vantage point.

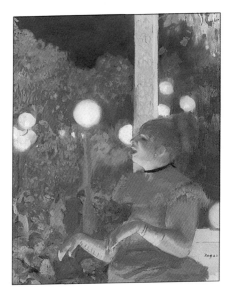

WOMEN ON THE TERRACE OF A CAFÉ IN THE EVENING

1877; PASTEL OVER MONOTYPE ON PAPER;
16 ⅛" × 23 ⅝" (41 × 60 CM);
MUSÉE D'ORSAY, PARIS

The subject, prostitutes chatting in a boulevard café, caused a sensation during the third Impressionist exhibition in 1877, where it overshadowed even *The Absinthe Drinker* (see page 34) shown in the same room. Some saw in Degas nothing but a relentless critic of the bourgeois. In fact, Degas offers an astute but cynical observation of human behavior in a tightly composed painting.

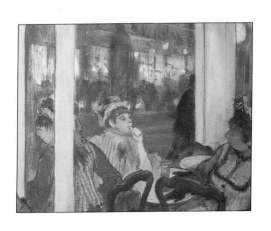

WOMAN WITH FIELD GLASSES

CIRCA 1875–1876; OIL ON CARDBOARD;
18 $\frac{7}{8}$" × 12 $\frac{5}{8}$" (48 × 32 CM);
STAATLICHE KUNSTSAMMLUNGEN,
NEUE MEISTER, DRESDEN

A unique case in which the common relationship between the viewer and the viewed is reversed. Degas treated this powerful image various times and it seems plausible that he intended to include the figure in one of his depictions of race tracks, although he apparently never did, perhaps because the haunting figure defeated any attempt at successful integration. The work was given by Degas to his friend and fellow painter James Tissot.

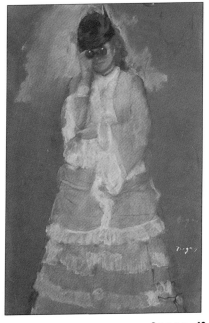

AT THE STOCK EXCHANGE
CIRCA 1878–1879; OIL ON CANVAS;
39 ³/₈" × 32 ¹/₄" (100 × 82 CM);
MUSÉE D ORSAY, PARIS

> Only apparently chaotic, this scene of the Paris
> Stock Exchange is grounded by architectural
> elements in the background. At the center, wear-
> ing eye glasses, is the successful financier Ernest
> May studying a document presented by a secre-
> tary or an usher while his companion is leaning
> forward in order to take a closer look. The paint-
> ing, commissioned by May, was left unfinished
> and was bequeathed to the Louvre after May's
> death.

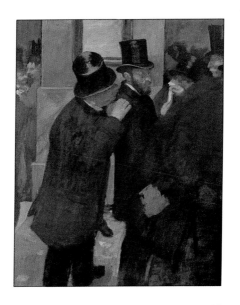

THE RACE TRACK, AMATEUR JOCKEYS NEAR A CARRIAGE

BEGUN 1876, COMPLETED 1887; OIL ON CANVAS; 26″ × 31 ⁷⁄₈″ (66 × 81 cm); MUSÉE D'ORSAY, PARIS

Race tracks were one of Degas' favorite subjects, and this composition is among the most monumental and original scenes. Although casually set in the countryside, one should not overlook the crowd of spectators in the distance who form a human wall waiting for the race to start. Farther behind them, a train passes by, a movement echoed by the speeding horse to the left. On the far right the two onlookers with their carriage, amusingly characterized by their hats, obviously belong to an urban society.

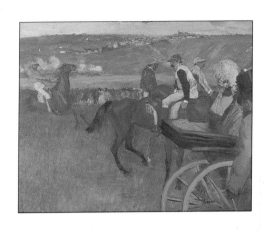

BALLET REHEARSAL ON STAGE

1874; OIL ON CANVAS;
25 ⅝" × 31 ⅞" (65 × 81 CM);
MUSÉE D'ORSAY, PARIS

This painting was remembered in a letter by the
Italian Impressionist painter Giuseppe de Nittis,
who had seen it during the first Impressionist
exhibition in 1874, as "...extremely beautiful. The
muslin dresses are so diaphanous and the move-
ments so true that only seeing it could give you
an idea; describing it is impossible." Obviously
intended to be used as a model for an engraver,
the work was executed by Degas in thin layers of a
single color of paint.

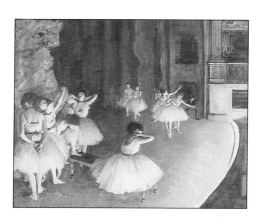

Two Ballerinas on Stage

1874; OIL ON CANVAS;
24 ¼" × 18 ½" (61.5 × 46 CM);
THE COURTAULD INSTITUTE, LONDON

The composition of this highly finished canvas is focused on only two ballerinas in standard ballet positions. There is no clear indication, however, whether the scene is meant to be read as a performance or a rehearsal. Behind the dancers are stage-flats that suggest foliage. The tutu of a third dancer in the rear of the stage is cut by the frame on the far left. Exhibited at the Society of French Artists in London in November of 1874, the painting was immediately acquired by a British collector.

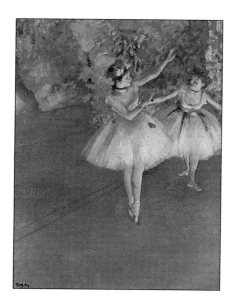

Dance Class

BEGUN 1873, COMPLETED 1875–1876;
OIL ON CANVAS; 33 $\frac{1}{2}$" × 29 $\frac{1}{2}$"
(85 × 75 CM); MUSÉE D'ORSAY, PARIS

The famous baritone and art collector Jean-Baptiste Faure commissioned Degas to paint a dance scene for him, which resulted in a series of works on this subject. This painting was Degas' first attempt at a large-scale dance scene. The light and almost translucent handling of paint makes the efforts required to produce the work almost unnoticeable. The scene appears to represent a break during a dance class, allowing the students to relax. Degas eventually produced a different version of this that he presented to his patron.

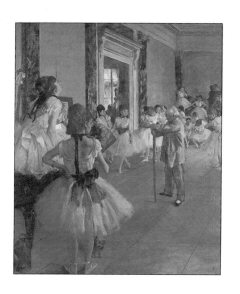

The Ballet Star

1876–1877; Pastel over monotype;
22 ⁷/₈" × 16 ¹/₂" (58 × 42 cm);
Musée d'Orsay, Paris

This painting features the magical moment of a dancer's solo performance as seen from a stage box. In the wings other dancers await their turns while a male figure dressed in a black tuxedo, perhaps the star's "protector," appears as a passive onlooker. The star is singled out by the bare stage surrounding her. This and other dancing scenes by Degas were revered by the contemporary critic Georges Rivière, who said, "After having seen these pastels, you will never have to go to the Opéra again."

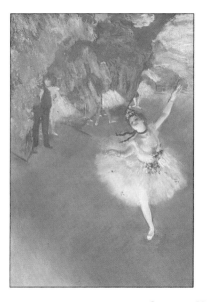

BALLERINA WITH BOUQUET OF FLOWERS

CIRCA 1877; PASTEL AND GOUACHE ON PAPER;
28 3/8" × 30 1/2" (72 × 77.5 CM);
MUSÉE D'ORSAY, PARIS

Degas hardly ever depicted actual ballet performances. He preferred a rehearsal or the aftermath of a theater evening, as shown here. The prima ballerina, honored by one of her fans with a bouquet of flowers, is taking a curtain call. Her smile is frozen in the glaring footlight harshly illuminating her face from below. The ballet scene derives from the third act of Massenet's opera *Le Roi de Lahore,* indicated by the Hindu costumes of the background figures.

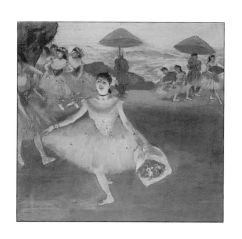

PORTRAIT OF MME. JEANTAUD AT THE MIRROR

1875; OIL ON CANVAS; 27 ½" × 33"
(70 × 84 CM); MUSÉE D'ORSAY, PARIS

Madame Jeantaud was the wife of one of Degas'
friends. By introducing a mirror, the artist shows
the elegant model both in profile and from the
front. In this way, the painting offers a complex
spatial rendering. The model's decorative hat and
her elegant pose seem to foreshadow *The Millinery
Shop* (see page 67), which Degas painted a cou-
ple of years later.

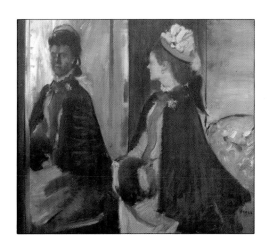

DIEGO MARTELLI

1879; OIL ON CANVAS;
43 ¹/₂" × 39 ³/₄" (110 × 100 CM);
NATIONAL GALLERY OF SCOTLAND,
EDINBURGH

Diego Martelli was a Florentine writer and art critic and the principal advocate of the Italian Impressionist movement called the Macchiaioli. He visited Paris several times and became friendly with Degas, albeit with some reservations. The most characteristic feature of this portrait is its unusual angle, which looks down on the model from above. The result is a sharp foreshortening of the sitter's legs and an abruptly receding floor.

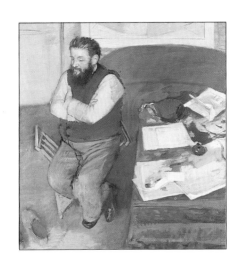

Ironing Women (The Laundresses)

CIRCA 1884–1886; OIL ON CANVAS;
30" × 31 ⅞" (76 × 81 CM);
MUSÉE D'ORSAY, PARIS

Two laundresses, unaware of the artist or viewer, are caught in a moment of their dull and joyless work. Degas painted this work on an unprimed canvas, a unique case for him, and attempted to simulate the various textures and qualities of fabrics such as the yellow wool shawl or the starched linen shirt that is being pressed. The lively, chalky surface looks as though it was in pastel. The most striking feature of this painting, however, is the telling and somewhat comical gesture of the woman yawning in oblivion.

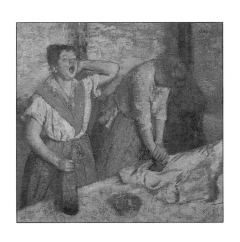

MARY CASSATT

CIRCA 1884; OIL ON CANVAS;
28 ½" × 23 ⅛" (71.5 × 58.7 CM);
NATIONAL PORTRAIT GALLERY, SMITHSONIAN
INSTITUTION, WASHINGTON, D.C.

The American painter Mary Cassatt presumably received this portrait as a gift from Degas, who in turn acquired one of her paintings, which he kept in a place of honor in his apartment. The two artists collaborated on a common project of an unrealized journal. Their friendship notwithstanding, many years later Cassatt expressed her dislike of this portrait, perhaps because it shows her in an improper posture holding tarot cards like a fortune-teller. Cassatt evidently destroyed Degas' letters to her and there is no detailed information available about the nature of their relationship.

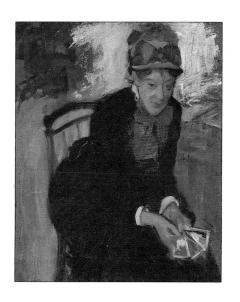

THE MILLINERY SHOP

CIRCA 1882–1886; OIL ON CANVAS;
39 ⅛" × 43 ½" (100 × 110.7 CM);
ART INSTITUTE, CHICAGO

A woman in a millinery shop examines a hat. The composition develops around the woman's bent elbow, which is set on the corner of the table where several other hats are on display. As in the portrait of Diego Martelli (see page 60), the room is seen from an elevated vantage point looking down at the model who wears a plain olive-colored wool skirt and long gloves. It is likely that the young woman is actually a salesperson adjusting a newly created hat rather than a client looking to buy a hat.

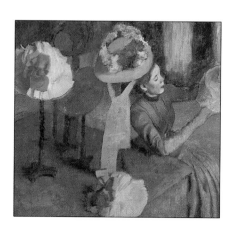

HÉLÈNE ROUART

1886; OIL ON CANVAS;
63 ³/₈" × 47 ¹/₄" (161 × 120 CM);
NATIONAL GALLERY, LONDON

> The daughter of Degas' high school friend, the
> painter Henri Rouart, is shown in her father's studio
> in the rue de Lisbonne. Standing majestically behind
> an impressive armchair, Hélène seems oblivious to
> the viewer's presence. The unusually large painting
> is a monument to the extraordinary relationship
> between Degas and the Rouarts, whom he once
> called his only family "in France." For years Degas
> was a regular dinner guest at their house.

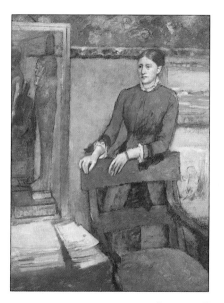

RACEHORSES BEFORE THE STANDS

1866–1868; ESSENCE ON PAPER MOUNTED
ON CANVAS; 18 ¹⁄₈" × 24" (46 × 61CM);
MUSÉE D'ORSAY, PARIS

A novelty both in composition and in the highly personal technique in which this painting is executed – the artist applied a unique essence on paper then mounted the paper on the canvas – this work has enjoyed great popularity. Its history, however, remains largely a mystery. The location cannot be clearly identified and might be a free interpretation of a race track near Paris. The public in the stands is separated by a thin barrier of white wood from the horsemen who cast long shadows, indicating a late spring or summer afternoon. The calmness of this scene reveals nothing of the excitement usually attributed to this location.

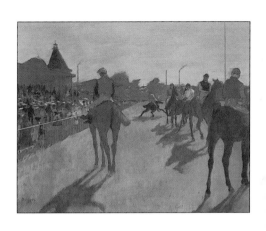

BALLERINA AND WOMAN WITH UMBRELLA ON A BENCH (L' ATTENTE)

CIRCA 1882; PASTEL ON PAPER;
19" × 24" (48.2 × 61 CM);
THE J. PAUL GETTY MUSEUM, MALIBU,
CALIFORNIA (OWNED JOINTLY WITH THE NORTON
SIMON MUSEUM, PASADENA, CALIFORNIA)

Traditionally, the subject of this pastel has been interpreted as a young dancer from the provinces who is waiting with her mother for an audition. The older woman dressed in black forms a striking contrast with the colorful dancer rubbing her sore ankle. Both figures remain anonymous in their individual solitude. The drabness of this backstage scene is emphasized by the empty space surrounding the two figures. The umbrella serves to define depth.

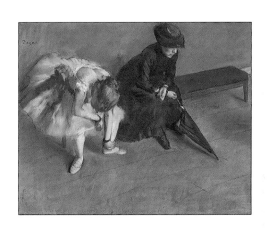

BALLERINAS CLIMBING A STAIRCASE

1886–1890; OIL ON CANVAS;
15 3/8" × 35 1/4" (39 × 89.5 CM);
MUSÉE D'ORSAY, PARIS

This room, in which a number of dancers are getting prepared for a rehearsal, is probably part of the Opéra. The horizontal arrangement of the composition and the complete absence of any architectural decoration underline an austere work atmosphere. In the foreground, a ballerina climbs gracefully up the stairs adjusting her dress before joining her fellow dancers in the rear of the hall. Another young woman is bending backward, obviously talking to another person.

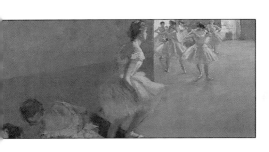

FOUR BALLERINAS BEHIND THE STAGE

CIRCA 1898; PASTEL;
26" × 26 ⅜" (66 × 67 CM);
PUSHKIN MUSEUM, MOSCOW

The intense blue pastel colors and the rhythmic play with the dancers' poses are the most important message of this work. It is entirely possible that Degas used the same model for all four figures. He might have revolved around her in order to examine every angle, and then compressed his studies into one group. The typical gestures of stretching their limbs or adjusting their outfits make this a charming, intimate scene.

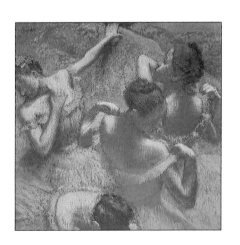

THE GREEN DANCER (DANCERS ON THE STAGE)

CIRCA 1880; PASTEL AND GOUACHE ON PAPER;
26″ × 14 ¼″ (66 × 36 CM);
THYSSEN-BORNEMISZA COLLECTION,
LUGANO, SWITZERLAND

The stage is seen from a box near the proscenium arch. The green dancer in the foreground in an arabesque is part of a group of dancers of which only another limb and a tutu is visible. Their diagonal movement is counterbalanced by the horizontal frieze of dancers dressed in orange who await their cue at the rear of the stage. This is Degas' most challenging attempt to draw the viewer into the midst of a performance.

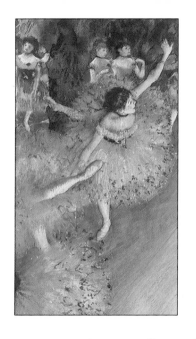

HARLEQUIN AND COLOMBINA

CIRCA 1886; PASTEL;
16 ⅛" × 16 ⅛" (41 × 41CM);
KUNSTHISTORISCHES MUSEUM, VIENNA

While most dance scenes are of a generic charac-
ter, a few specific ballets in Degas' oeuvre
can be identified. The characteristic patchwork
of Harlequin's costume allows the viewer to
distinguish a group of paintings inspired by the
ballet *Les Jumeaux de Bergame* (The Twin
Brothers from Bergamo), a farce in the tradition
of the Italian commedia dell'arte. In this
scene, Harlequin, with a stick behind his back,
appears as an aggressive suitor to his beloved
Colombina. The slapstick atmosphere of such a
performance seems to have intrigued the artist.

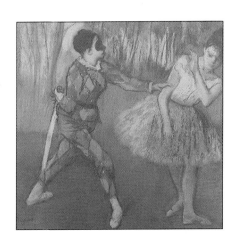

MISS LALA AT THE "CIRQUE FERNANDO"
1879; PASTEL;
24" × 18 ¾" (61 × 47.6 CM);
TATE GALLERY, LONDON

The acrobat Lala is said to have been a black or mulatto woman who performed acts of strength at the Cirque Fernando, a well-known circus in the Montmartre district of Paris. She is holding a rope between her teeth while being pulled up to the roof of the circus tent. The focus of the composition is the woman's compact body swirling at the end of the rope. Degas had a chance to witness this demonstration of physical strength during a visit to the circus on January 24, 1879, as the date of the work indicates.

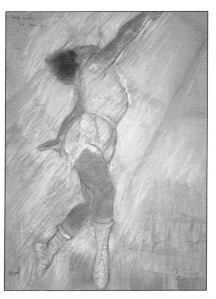

WOMAN AT HER BATH
CIRCA 1895; OIL ON CANVAS;
28" × 35" (71 × 89 CM);
THE ART GALLERY OF ONTARIO, TORONTO

About a third of Degas' work of the 1890s consists of images of bathing women. The models were asked to move freely around in the artist's studio, in which a bathtub had been placed. "These women of mine are honest, simple folk, unconcerned by any other interests than those involved in their physical condition," Degas once said. The strong, exotic colors of the violet and rose bathtowels animate this composition in which a woman taking her bath is being assisted by a maidservant pouring water out of a blue jug over the bather's shoulders.

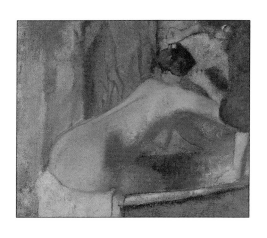

WOMAN DRYING HER NECK AFTER THE BATH

CIRCA 1895; PASTEL ON PAPER;
24 ½" × 25 ⅝" (62.2 × 65 CM);
MUSÉE D'ORSAY, PARIS

Having just finished her bath, a woman dries her hair and neck while sitting on the edge of the tub. Degas himself seems to have used the tub daily: "In the morning, I bathe," he once explained to a visitor. Several vertical color fields animate the background, where one can distinguish a chair and an orange robe. The woman's firm body was painted with light brushstrokes in pastel colors. The natural gestures of Degas' models supersede the impression that they might be prostitutes.

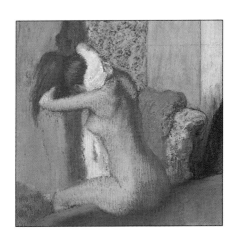

AFTER THE BATH (KNEELING WOMAN DRYING HER LEFT ELBOW)

CIRCA 1895; PASTEL ON PAPER;
27 5/8" × 27 5/8" (70 × 70 CM);
MUSÉE D'ORSAY, PARIS

The bather is sitting on a towel on the floor drying her left elbow. To the right is a yellow chair on which another white towel or a robe has been placed. Behind the woman's back we see a purple slipper and a curtain that brings the figure more to the foreground. Thick strokes of pastel (even in a reproduction one can see the texture of the material on the paper's surface) define the body with light and shades. The open space around the woman makes this intimate moment accessible to the viewer.

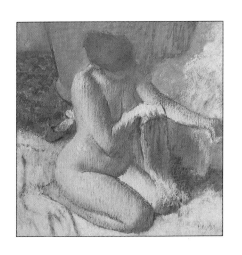

Little Dancer Aged Fourteen

1880–1881; Bronze, with muslin skirt
and satin hair ribbon;
38 ³/₄″ × 16 ¹/₂″ × 14 ³/₈″
(98.4 × 41.9 × 36.5 cm);
Tate Gallery, London

The model for this sculpture was a young Belgian girl, Marie van Goethen, who was then a ballet pupil at the Opéra. Degas modeled the work first in wax, then made several bronze casts, of which this is one. An unusual feature for a sculpture is that the girl wears a real dress and a satin ribbon, which heightens the natural feeling of the girl's pose. This was the only sculpture exhibited during the artist's lifetime.

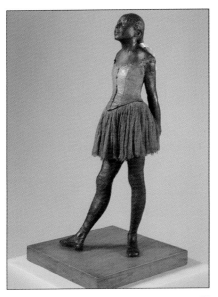

GRANDE ARABESQUE

1885–1890; BRONZE;
15 ³/₄" × 20 × 13 ¹/₂"
(40 × 50.8 × 34.3 CM);
TATE GALLERY, LONDON

The grace of movement is perfectly captured in this
ballerina leaning forward in a position known as a
Grande Arabesque. Degas, who had an intimate
knowledge of the ballet, made several other sculp-
tures in this attitude but in different positions.
Striving for perfection of form, the artist repeated his
motifs throughout his career, moving freely from
painting to drawing to sculpture. This last medium,
however, remained a private aspect of his work, for
only one of his sculptures was displayed during his
lifetime (see page 90). After 1880 Degas' eyesight
began to fail and he eventually became totally blind.

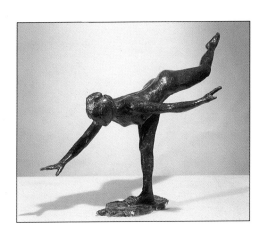

INDEX OF ARTWORKS

PHOTOGRAPHY CREDITS

Art Resource, New York pp. 19, 81
Bridgeman/Art Resource, New York pp. 61, 69
Collection of the J.Paul Getty Museum, Malibu, California, p. 73
Giraudon/Art Resource, New York pp. 23, 31, 45, 49, 55, 59, 75,
 87, 89
Erich Lessing/Art Resource, New York, front jacket, pp. 4, 13, 15, 17,
 21, 25, 29, 33, 35, 37, 39, 41, 47, 53, 63, 67, 71, 79, 85
Metropolitan Museum of Art, Bequest of Mrs. H.O. Havemeyer, 1929.
 The H.O. Havemeyer Collection. (29.100.184) p. 27
©1993 National Gallery of Art, Washington, D.C., Chester Dale
 Collection p.11
National Portrait Gallery, Smithsonian Institution. Gift of the Morris and
 Gwendolyn Cafritz Foundation and the Regents' Major Acquisitions
 Fund p. 65
Scala/Art Resource, New York pp. 51, 57, 77
Tate Gallery, London/Art Resource, New York p. 83, 91, 93